101

Glimpses of Long Island's
North Shore

RICHARD PANCHYK

Charleston — London

THE
History
PRESS

Published by The History Press
Charleston, SC 29403
www.historypress.net

Copyright © 2008 by Richard Panchyk
All rights reserved

First published 2008

Manufactured in the United Kingdom

ISBN 978.1.59629.535.3

Library of Congress CIP data applied for.

Contents

Foreword

I grew up on the North Shore, swimming in the sound, fishing off the jetties and exploring its woods. My father was a young boy in 1925 when he moved to Glen Cove from Italy with his family. My parents continued to make Glen Cove their home after they got married and raised my three brothers, sister and me here. I proposed to my wife Helene (who also grew up on the North Shore) in Morgan Memorial Park and now we take our children to visit North Shore's treasures. I have traveled to many places throughout the world and there is simply no place like it.

From the Matinecock tribe to the Gold Coast mansions to the sailboat regattas of today, the North Shore makes history come alive. Native Americans like the Matinecock live on, not just in the names of our villages and hamlets, but in the archaeological exhibits and continuing research at Garvies Point Museum and Preserve. During the Revolutionary War, George Washington traveled along what we now call Northern Boulevard.

The historic Gold Coast was once home to some of the world's most powerful and wealthiest families, including J.P. Morgan, the Guggenheims, the Woolworths and the Rockefellers. Over a dozen of the world's grandest mansions are set on sprawling estates on Nassau County's North Shore and they allow us to time travel back to the turn of the last century. Theodore Roosevelt's beautiful Victorian estate still stands on Sagamore Hill.

Our North Shore is home to the U.S. Merchant Marine Academy, Tilles Center, Webb Institute, Coe Hall at Planting Fields Arboretum, Old Westbury Gardens, Raynham Hall and the Harrison House. The Nassau County Museum of Art is considered by many to be the nation's largest suburban fine arts museum and the Americana offers all the designer shops that adorn Fifth and Madison Avenues in Manhattan.

The North Shore also boasts beautiful New England–style downtowns, such as the historic villages of Roslyn and Sea Cliff, the historical hamlet of Oyster Bay and downtown Locust Valley. This area was made famous by F. Scott Fitzgerald's novel, *The Great Gatsby*, and countless movies such as *Annie Hall*, *Sabrina*, *Love Story*, *Scent of a Woman* and *Batman Forever*.

The North Shore is lined with miles of pebble-strewn beaches and serene natural waterfronts. Here on the North Shore, one can hike bluff-top trails overlooking the Long Island Sound, tramp through hundreds of acres of the Welwyn and Muttontown Preserves, observe flocks of osprey

and red-tailed hawks and take advantage of all the activities at Sands Point. (Children are often enchanted by its castle-like Hempstead House.) Residents and visitors alike love picnicking at Old Westbury Gardens during the spring, when its magnificent trees are in full blossom.

You'll find these North Shore treasures, and many more, as you leaf through the pages of this wonderful book. Richard Panchyk has sifted through the historical archives to give us a glorious chapter of Long Island's ongoing story. I hope you find the North Shore as beautiful and inspiring as I do.

Thomas R. Suozzi
Nassau County Executive

Preface

I have studied history, historic preservation and the changing face of various communities in Queens and Nassau Counties for nearly twenty years now. I first touched upon the topic of historic preservation in my undergraduate thesis at Adelphi University, and then again in my graduate work at the University of Massachusetts. I also discuss preservation in one of my earlier books, *Archaeology for Kids*, but then not again until recently with *A History of Westbury, Long Island* (2007). It was that book that really excited the local historian in me, and quickly led to another local-oriented book, *Forgotten Tales of Long Island* (2008). That book relies upon old and often obscure stories and folklore, rather than images, to reveal glimpses of the past on Long Island.

Naturally, when my editor at The History Press suggested this particular project, I thought that it would be a perfect fit for me. The idea of an image-oriented book appealed strongly to me, and even more importantly, the idea of communicating a story via old photographs was very appealing. Over the past ten years, I have selected more

than one thousand images for use in my various books. I understand the power a historic image can possess to reveal the mysteries of the past. Pick up almost any nonfiction book in a bookstore and what do you look for first? It is the pictures that bring many books to life.

I have always been fascinated with the past, as far back as I can remember. First, I am interested in the ways in which we celebrate and remember our heritage, preserving it for future generations to know and understand. Yet I am perhaps even more curious about the ways in which we often try to forget the past and obliterate any of its remaining traces. The struggle between preservation and progress is a mighty and ongoing one around the country, but especially in an area such as Long Island, where land values have become so high and the housing crunch has become so critical. It seems that our society is enamored of all things new, including technology and buildings. We sometimes look with disdain upon the old and traditional, wanting instead to get the newer and better. One problem is that renovation and restoration can quickly become more costly and difficult than new construction. Thousands of historic Long Island structures await restoration, and some of these are seemingly destined for the wrecking ball. But the wrecking ball is a necessary evil, because without any new construction, we would be completely stuck in the past, without the proper facilities and infrastructure to lead modern lives.

At the same time, it is critical that we recognize that "new" has its own share of problems, and that the wholesale disposal of "old" is not beneficial. In many cases, the old saying "they don't make them like they used to" holds true. Old buildings are generally more solid and last longer than newer ones. In the days when people built their own homes or oversaw every detail of their construction, extra care was taken to make strong and lasting buildings. How often we read about this new building or that new structure that has a problem, was built wrong or was constructed with shoddy materials. Besides, a society cannot simply discard its past, if only because the past offers valuable lessons and helps us understand where we came from and can also offer warnings about where we are going.

Thanks to two New Deal–era programs begun in 1933 during the Great Depression, under the presidency of Franklin D. Roosevelt, a record of some of the historic structures of Northern Nassau and Suffolk Counties has been preserved. Under the Historic American Buildings Survey (HABS) and Historic American Engineering Record (HAER), thirty-five thousand structures around the country dating to the seventeenth, eighteenth and nineteenth centuries were thoroughly documented in photographs, drawings and captions. It is impossible to know how many of these structures remain intact, but it is certainly fair to say that a great number of them have since been demolished, some within only a few years of their documentation.

The Nassau County Museum Collection is another great historical resource, with thousands of images. It is a blessing that there exists one central archive containing so many images showing life in Long Island's past. The turn-of-the-century Sea Cliff photographer Henry Korten, whose work represents some of the most thorough documentation of early twentieth-century life on the North Shore, took several of the Nassau County images in this book.

Acknowledgements

I want to extend a very special thank-you to the terrific Nassau County Executive Thomas Suozzi for taking the time to contribute a foreword. I have known how deeply he cares about the North Shore since he was mayor of Glen Cove, and he has clearly carried that passion with him as he serves the county. Also thanks to Laura Williams at Nassau County for all her wonderful help and coordination. Thanks to George William Fisher at Nassau County, who went out of his way to ensure that my photographic needs were promptly met. Also thanks to Tracy Kay and Gary Hammond at Nassau County for their gracious assistance in helping me obtain some of the images in the book. Thanks to Katharine Powis of the New York Horticultural Society and Susan Kovarik of the Historical Society of the Westburys for their help and kindness. Thanks to Jean Prommersberger for providing images. I also want to thank my editor at The History Press, Jonathan Simcosky, for bringing me this interesting project. Also thanks to the whole dedicated team at The History Press, including Brittain Phillips, Saunders

Robinson, Dani McGrath, Katie Parry and Catherine Clegg. And thanks to Caren and the rest of my family for their continued support.

Photo Credits
Historical Society of the Westburys: 27, 36, 42, 61–63, 68 (top), 79, 100, 112 (bottom), 113 (bottom), 118–19
Author's Collection: 54, 57–60, 66, 71, 113 (top), 115
Horticultural Society of New York: 88–89, 91–97
Nassau County Museum Collection: 51–53, 55–56, 65, 67, 68 (bottom), 109–11, 112 (top), 123, 126
Jean Prommersberger: 72, 128

Author's Note

Today, the words "Long Island" refer to Nassau and Suffolk Counties. However, for hundreds of years, and even for some years after the consolidation of Queens and Brooklyn into New York City in 1898, when someone referred to Long Island, they could in fact be referring to any point along the entire length of the island. Though Suffolk County existed before 1898, Nassau County did not; it was created from the eastern part of Queens County.

Though many of the photographs in the book are of northern Nassau County (the area that is considered the North Shore in the strictest interpretation of the term), there are also several images of North Shore communities in Suffolk County, and even a few images of the northern reaches of what is now Queens County. I prefer to take a holistic approach to the topic, to give a more complete and sweeping view of the communities along the northern shore of the island, recognizing the days when the boundaries within the island were less distinct (especially where Queens versus Nassau is concerned).

This book is meant to provide glimpses of a bygone era, the days before the Miracle Mile, the Long Island Expressway and the Northern State Parkway. Naturally, huge volumes could be published to document each of the many North Shore communities in photographs. In fact, many communities are already celebrated in their own photo compilations. However, the intent of this little book is not to provide comprehensive documentation of any one place in particular, but rather to give a sweeping view across the North Shore at various people, places and events from the late nineteenth to the mid-twentieth centuries.

The North Shore holds fond memories for me—from a childhood trip to Oyster Bay to college weekends on an archaeological excavation at Leeds Pond in Plandome and trips to the shore in Sea Cliff. I have carefully selected the images in the book, and have tried to represent as many different communities as possible. I hope that you enjoy this book.

Introduction

North versus South

Anyone who lives on Long Island understands that there is a clear distinction between North Shore and South Shore. To the outsider, it may seem most curious that there could be such a sharp dichotomy within a place that is so narrow in width. Yet no one can deny that there is a very certain distinction. For one, the geography is quite different. Long Island represents the "terminal moraine," marking the point of farthest southern advance of the glaciers during the last ice age. Where glaciers advanced and retreated along the North Shore, it is more hilly and rocky than the southern half of the island. Where outwash was pushed ahead of the glaciers, the southern parts of the island are more prone to be flat. The South Shore includes features such as marshes, swamps and grasslands, while the North Shore includes woodlands and forested areas. The North Shore leads to the relatively calm Long Island Sound, with its views of Connecticut, harbors and coves lined with boats. The North Shore is also the gateway

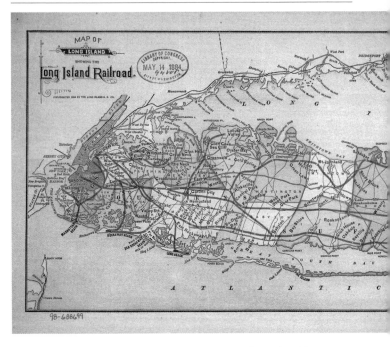

Long Island Rail Road map showing the system as it was in 1884.

to New York City, Westchester and Connecticut because of its ferries and nearby bridges. On the other hand, the South Shore leads to the great expanse of the Atlantic Ocean, with its frothy waves licking at the beaches, and is the gateway to the Belt Parkway, Brooklyn and Staten Island.

Besides these clear physical, geographical differences, there are other, more social differences. Think of Northern Boulevard

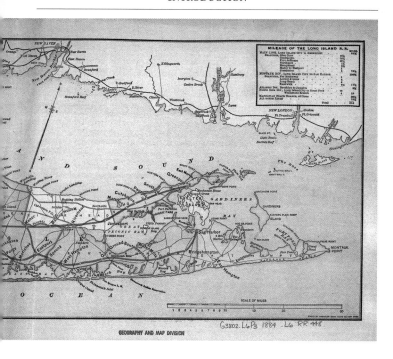

versus the Sunrise Highway. For another example, compare Massapequa and Glen Cove, or Merrick and Sea Cliff, and it is clear that you are contrasting oranges with apples. This is true despite the fact that communities both on the North and South Shores have served as summer resorts for over 150 years.

I will also admit that there exists what can best be called a gray area, a narrow strip along the center of the island.

In Nassau County, part of this questionable central area falls into what is called the "Nassau Hub," encompassing parts of Carle Place, Westbury, Mineola, Uniondale, Hempstead and Garden City. Though this swath of land's North-South status may be questionable, it would seem that in Nassau County, anything below Hempstead Turnpike can be considered South Shore and anything above Jericho Turnpike (Route 25) or Hillside Avenue (Route 25B) is North Shore, depending on where in Nassau County you are. The township boundaries also offer a clue—Hempstead ends and North Hempstead begins roughly where the North Shore region begins.

A Thriving Place

We like to think that Long Island's North Shore communities were founded by the Dutch or English back in the 1600s. But in fact, Native Americans had settled the North Shore and found it to be quite an attractive place to live thousands of years before Henry Hudson sailed to the New York area in 1609. Native Americans were settled throughout the North Shore of Long Island, but countless thousands were either assimilated or eradicated not long after the Europeans moved in. All that they leave behind today are some archaeological relics and place names such as Setauket, Manhasset and Caumsett.

The Europeans on the North Shore lived off the bounty of the land and the sea; farming, fishing and whaling

were keys to their success. They lived in small settlements, passing a quiet, almost rural existence that continued until the second or third quarter of the nineteenth century. The only major disturbance up to that time was the American Revolution, during which time the British occupied Long Island. Many adventures marked this occupation, including tales of Loyalist spies, Tory revenge and the pilfering of food and valuables. Within a few years of the Revolution's end, life was back to normal on the North Shore.

The relatively stable population began to increase dramatically in the mid- to late nineteenth century, as many thousands of Irish, German, Polish and Italian immigrants arrived. Along with new technology and progress during that period came the need for a wide variety of laborers who laid railroad and trolley tracks, built roads and helped construct and maintain the lavish estates of the millionaires who came during the late nineteenth and early twentieth centuries. Landscapers, masons, electricians, plumbers, chauffeurs, grooms and stablemen, maids and cooks were all needed. Because there was so much full-time work to be had, many of these workers wound up settling in the area, adding population to communities such as Roslyn, Great Neck and Glen Cove. Still, the population of the North Shore was not as great as that of the South Shore. In 1925, Hempstead had a population of over 122,802, while North Hempstead was only 41,515 and Oyster Bay (mostly North Shore but includes a sliver of South Shore territory) only 29,610. By

the year 2000, North Hempstead's population had reached 222,611.

Playground of the Rich and Famous

During the late nineteenth century, the titans of Wall Street finance and big business industry began to look to the North Shore of Long Island as an idea location for their homes. In many cases, the gigantic mansions they constructed in Glen Cove, Brookville, Roslyn, Old Westbury and other places were only summer homes, escapes from their palatial Fifth Avenue mansions. Among the wealthy residents of the North Shore were J.P. Morgan, Henry Davison, John Mackay, Walter Chrysler, Marjorie Merriweather Post and Frank Woolworth. Besides the titans of Wall Street, the North Shore was also a haven for the stars of screen and stage during the early twentieth century. Countless Hollywood and Broadway stars owned or rented exclusive summer homes in one of the many towns in Northern Nassau and Suffolk Counties, including Basil Rathbone, W.C. Fields and Groucho Marx. The most famous North Shore resident, however, was neither Wall Street wizard nor movie star—it was Theodore Roosevelt, who spent many weeks of his presidency at his home in Oyster Bay.

Theodore Roosevelt was not the only one who helped spread the fame of the North Shore through the rest of the

country. The legend of the "Gold Coast" was preserved in novelist F. Scott Fitzgerald's 1920s masterpiece *The Great Gatsby*. Though Fitzgerald lived in Great Neck for a relatively short time and completed the famous novel in France, his impressions of the North Shore elite in the fictitious town of West Egg became cemented in American popular culture. Some of Fitzgerald's characters were actually based on North Shore people he knew.

The glory years of the Gold Coast passed relatively quickly, peaking during the Roaring Twenties. The great majority of these grand old estates are now long gone. The huge palaces built by the titans of industry were simply too expensive to maintain, especially after the Great Depression hit, followed by World War II. As well, by the 1940s, many of the original owners had died, and their descendants did not choose to remain. Unfortunately, the most cost-effective alternative for many of the mansions was simply to demolish them and then subdivide the extensive land (in many cases hundreds of acres) for the construction of expensive (though not quite as palatial) homes. The waterfront location of several of these estates also made them prime pieces of real estate.

Luckily, a few of the grand early twentieth-century estates still remain today. Falaise, the 1923 Harry Guggenheim estate at Sands Point (now part of the Sands Point Preserve); Welwyn, the Pratt mansion at Glen Cove (now a Holocaust museum); and the William Coe Estate at Oyster Bay (now part of the Planting Fields Arboretum complex) are some

examples. In those and a few other similar cases, preservation was achieved through government or nonprofit acquisition of the property. Others have been converted to some other use, such as Coindre Hall in Huntington and Oheka Castle, the magnificent 1917 chateau of financier Otto Herman Kahn in Cold Spring Harbor. The estates that survived the Great Depression are also memorialized in films, including Old Westbury's Phipps mansion in *North by Northwest* (1959), as are North Shore locales in general, such as Locust Valley in the remake of *Sabrina* (1995).

Not Just for the Rich

The North Shore of one hundred years ago was not just an endless stretch of fashionable beaches and sprawling mansions. There were also many villages with bustling downtowns featuring drugstores, post offices and dime stores. There were thriving farms and thousands of homes occupied by ordinary people. As mentioned earlier, in many cases, the rush to build colossal mansions fueled the local economy by providing jobs for hundreds and hundreds of men and women who would serve as carpenters, masons, electricians, plumbers, landscapers, grooms, coachmen, butlers, nannies and maids.

In fact, during the late 1800s and early 1900s, thousands of immigrants who arrived in New York City from all over Europe were drawn to the North Shore by the availability of

work. These immigrants helped bring a multicultural flavor to what had been primarily English settlements along the North Shore.

A Haven for Recreation

The North Shore has long been a place for sporting and recreation, but the super rich were not the only ones flocking to Long Island's North Shore. There were plenty of middle-class people from New York City who came in droves, especially during the summer. Sailing, swimming, horse racing, polo and flying were all important parts of life on the North Shore. Though these locales were celebrated as vacation spots in the country, northern Long Island was right at the center of the changing world. Exposure to two twentieth-century innovations—automobiles and airplanes—happened very early on the North Shore. William K. Vanderbilt brought automobile racing to the North Shore. In 1906, for example, the Vanderbilt Cup racecourse ran through Manhasset, Lakeville, Roslyn, Brookville and Old Westbury. Airplanes were flying over Mineola and points north as early as 1909.

The many recreation choices offered in northern Long Island not only attracted visitors and tourists, but also plenty of locals, who were thrilled to have such diverse amusements right in their backyards.

The Changing Face of the North Shore

In many ways, the North Shore communities of Long Island have changed a great deal from one hundred years ago. Gone are many of the amusement facilities, clubs and hotels of yore. In the late nineteenth century, most towns on the North Shore had several hotels to cater to overnight guests. The notion of Sea Cliff and other North Shore destinations as summer resort towns was transformed as transportation improved and especially after the Jones Beach complex on the South Shore opened in 1929.

The types of businesses that lined North Shore streets have changed as well. As the twentieth century progressed, society's needs and desires changed. For example, people of the late nineteenth and early twentieth centuries ate at home the vast majority of the time. Eating out under ordinary circumstances was practically unheard of. Restaurants as we know them today did not exist. Taverns and inns offered meals, but were primarily meant to serve travelers passing through. Those who were vacationing at one of the hotels along the North Shore could expect to take their daily meals at the hotel dining room, which was sometimes built to hold hundreds of diners.

As the twentieth century progressed, eating habits began to change. With the growing popularity of faster foods such as hamburgers and hot dogs, luncheonettes could offer patrons a quick bite, so they did not need to pack a lunch

An advertisement for Glen Cove from 1927.

or go home for lunch. And whereas in 1900 most business owners or workers in a given town might live in that town, by 1930 or so, this had changed. People were now just as likely to drive from Mineola to their place of work in Roslyn, or vice versa. For people who drove some miles to work, going home for lunch was not really an option anymore, and that contributed to the popularity of the diner. With these shifts, restaurants flourished, as both spouses were more likely to work and thus have less time for meal preparation. Another reason for the predominance of restaurants is because they offer a wide variety of exotic cuisine that people would or could not cook for themselves at home.

Much else has changed on Long Island. Gone are many of the old-time hardware stores, five and dime stores, meat markets, fruit and vegetable stores, bakeries and drugstores. Large-scale or chain stores have replaced them, big-box structures that offer a bigger variety and lower prices than the small stores could. So it is that the storefronts of North Shore downtowns of today look very different than they used to seventy-five years ago.

Back to the Past?

The pressure of increasing population, high prices and unchecked commercial development has threatened to alter the North Shore of Long Island. But despite the considerable

changes that have come to the North Shore, there are also many things that have not seemed to change over the course of time. For example, some stretches of quiet, winding country road still look much as they did in 1910. There are still old homes and barns, stately churches and waterfront vistas. There is still enough left to keep the North Shore a very special place.

Downtown revitalization, brownfields cleanup, historic reuse and other initiatives can help preserve the heritage while at the same time increasing local revenue by creating interest and drawing visitors. The North Shore of 1900 is gone, but today's North Shore possesses more reminders of the unique charms of yore than many other parts of Long Island. Now we are once again recognizing the value of our North Shore communities after some years of neglect and forgotten obligations. For example, the City of Glen Cove recently initiated an ambitious program to clean up industrial sites along the waterfront and generate a renewed and revitalized waterfront that will be an attractive place for both residents and visitors alike. Some locales are trying hard to encourage the reintroduction of mom and pop–type shops and luncheonettes back into their midst.

As long as we continue to celebrate the North Shore's rich heritage, we will ensure that we never destroy it. Some of the places you will see in this book are long gone, but many still exist today. Their tenacity is a combination of luck, hard work and respect for the past.

People

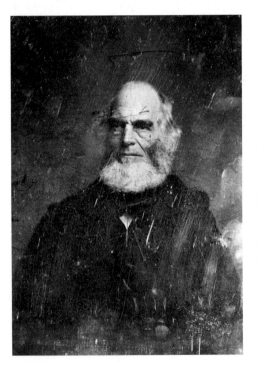

William Cullen Bryant (1798–1878) was one of the most famous residents of the North Shore. A prominent poet, Bryant later became editor of the *New York Evening Post*. Though he had a home in Massachusetts, from the 1840s until his death, Bryant spent much time at his beloved Cedarmere in Roslyn.

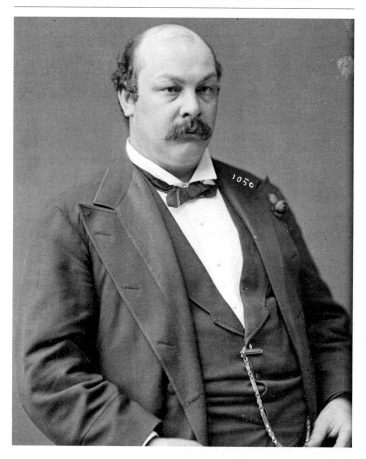

Benjamin Albertson Willis was a Congressman from Roslyn. He served from 1875 to 1879, and died in 1886 at the age of forty-six. The town of Albertson is named after the family from which Willis was descended. Like Willis, some members of Long Island's oldest families retained their mothers' maiden names or other family surnames as their middle names.

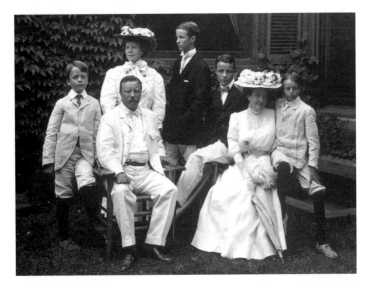

President Theodore Roosevelt (1858–1919) poses with second wife Edith and his six children: Alice (from his first marriage), Ethel, Theodore Jr., Archie, Kermit and Quentin, in about 1907. For the Roosevelt children, their home in Oyster Bay was a beloved place where they could spend quality time with their father.

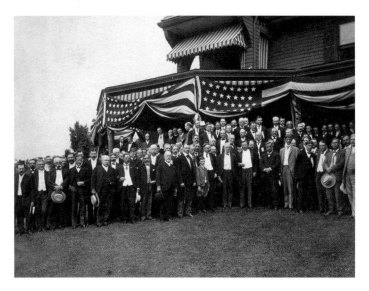

Members of the Republican Party Notification Committee visited President Roosevelt at Sagamore Hill on July 27, 1904. The purpose of the committee's trip was to officially notify Roosevelt that he had been selected as the Republicans' presidential candidate for the election that year.

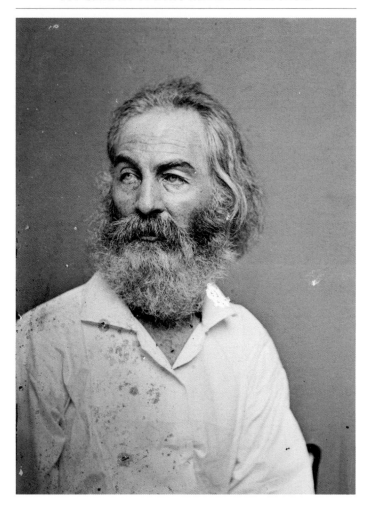

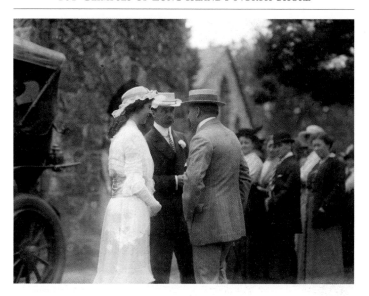

Clarence Mackay (1874–1938; at center) and his elder daughter Katherine, probably circa 1914. Mackay was the president of the Pacific Cable Company in Oyster Bay. The Mackay family lived at their Roslyn estate Harbor Hill and were well known within the community. Mackay, a Catholic, disowned his younger daughter Ellin when she married the Jewish composer Irving Berlin in 1926.

Opposite: Walt Whitman (1819–1892) was a poet and free spirit. Born in West Hills, he moved to Brooklyn at the age of four and returned to the Huntington area for a few years beginning in 1836. Though he only spent part of his life on Long Island, Whitman is identified with Long Island more than with any of the other places he lived. In fact, one of his major accomplishments while in Huntington was founding the town's first newspaper, the *Long-Islander*, in 1838.

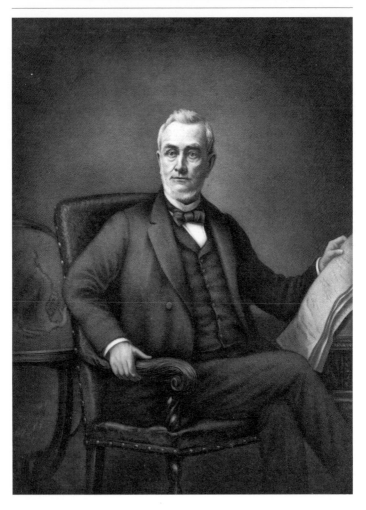

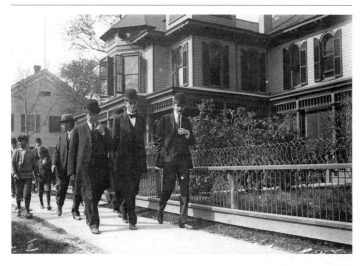

When Lieutenant Governor Lewis Stuyvesant Chanler (1869–1942) campaigned for governor of New York in 1908, he spent some time on Long Island. Here he is seen walking with some men down a street in Greenport. He lost the election to the Republican candidate, Charles Evans Hughes.

Opposite: John D. Jones (1814–1895) was a member of an old Long Island family that had lived in Oyster Bay since 1692. His father John owned mills and stores at Cold Spring Harbor and also ran a whaling fleet. John D. was president of the Atlantic Mutual Insurance Company in Manhattan. Though active in New York City, he kept a summer home at South Oyster Bay, where he died.

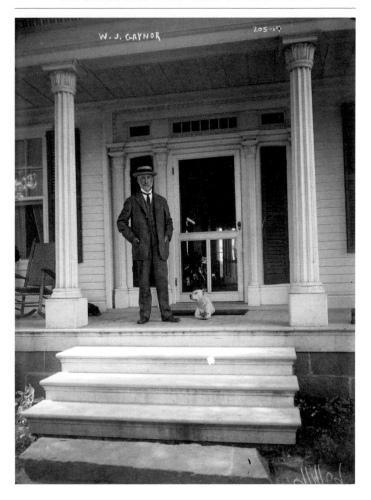

The English artist Herbert H. Gilchrist relaxes at the Moses Jarvis farm in Centerport Cove, where he lived for more than a year, circa 1890. Gilchrist was a friend of Walt Whitman's.

Opposite: William Gaynor (1849–1913) was the mayor of New York City from 1910 to 1913. He is seen here on the front porch of his summer home on North Country Road in St. James in 1910. Gaynor was famous for surviving an assassination attempt in August of that year. While he was recuperating, he received a telegram from five hundred of his neighbors in St. James wishing him a speedy recovery.

William Kissam Vanderbilt II (1878–1944) was the great-grandson of the tycoon Cornelius "Commodore" Vanderbilt, and was known as a sporting and auto-racing enthusiast. He was the motivating force behind Long Island's Vanderbilt Cup races, the first of which was run in 1904, and

Copyright
1903
Theo. C. Marceau
NY

Paris Panel #1

helped fund the Long Island Motor Parkway. He had a summer estate at Centerport (known as Eagle's Nest) that was left to Suffolk County and is now a museum.

Thomas Hitchcock Jr. (1900–1944), future polo star, stands next to Flora Payne Whitney, daughter of Harry Payne Whitney, in a photograph dating to about 1910. Flora Whitney would later be briefly engaged to Quentin Roosevelt, son of Theodore Roosevelt, before his untimely death in World War I.

Opposite: Sarah Rushmore Hicks (1790–1893), of what is now Old Westbury, was a member of one of Long Island's earliest families. Hicksville is named after the well-known Quaker family, which had branches in many Long Island communities, including Roslyn and Jericho.

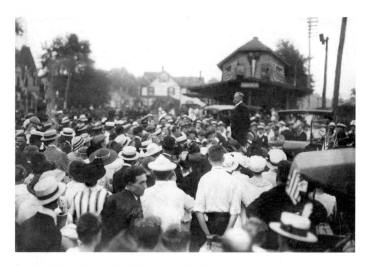

Retired Navy Rear Admiral Aaron Ward (1851–1918) speaks to a crowd in Great Neck in 1915. Admiral Ward lived in Roslyn after his retirement in 1912, and was known throughout the country for his expert rose cultivation.

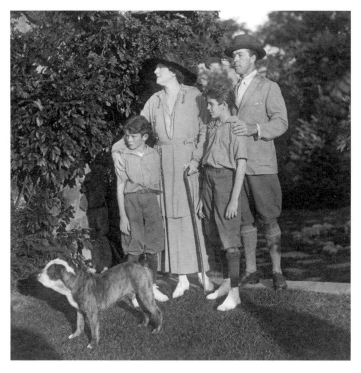

The British-born actor William Faversham (1868–1940) hit it big on Broadway. He lived on Long Island and is seen here in 1917 visiting Huntington with his family during a Red Cross benefit show.

Places

Theodore Roosevelt's Queen Anne–style home, Sagamore Hill, was built in 1885 at Cove Neck, just east of Oyster Bay. At the time he moved in, Roosevelt had recently lost his first wife, Alice. During his presidency, Sagamore Hill served as the summer White House. Roosevelt died there in 1919 and his widow Edith remained at Sagamore Hill until her death in 1948.

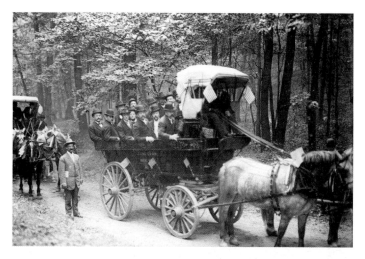

Men going to visit Theodore Roosevelt at Sagamore Hill in September 1908. The president did not spend his time at Oyster Bay idly. He met with many people, from diplomats to reporters, and accomplished work. Public access to Roosevelt at Oyster Bay, both during and after his presidency, was allowed.

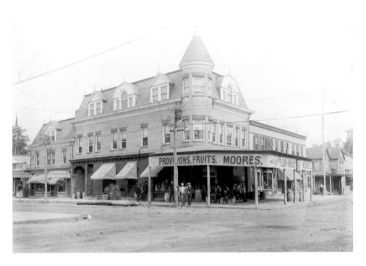

Downtown Oyster Bay during the early twentieth century was a dynamic place, first because the town was so close to the waterfront and second because Theodore Roosevelt could sometimes be spotted in town. This downtown building served as his office in town.

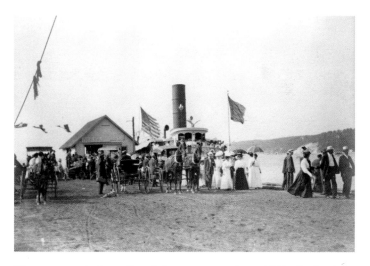

The steamer dock at Port Jefferson, seen about 1910. Ferries have transported passengers between Long Island and Connecticut for hundreds of years. Once they debarked, people were transported to their destinations by waiting carriages.

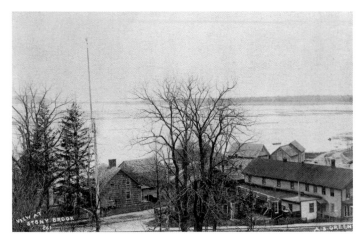

The view at Stony Brook, circa 1906, before its appearance was completely transformed by shoe tycoon Ward Melville. Between 1939 and 1941, Melville reconstructed the heart of the village in order to implement his vision for a historic Williamsburg, Virginia–type settlement.

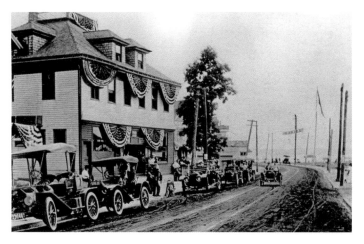

This image of Main Street in Port Washington dates to about 1910. The post office is the building on the left. Before North Shore roads were paved, they could become quite a muddy mess in the spring, after the snow melted.

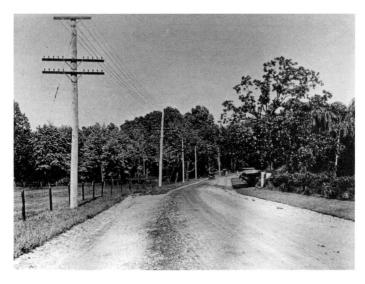

This is Lattingtown Road in Locust Valley as it appeared in 1910. Before the first modern highways were built on Long Island during the 1930s, though faster than travel by horse-drawn carriage, automobile travel was often slow, especially on winding North Shore roads.

The Manhasset Valley Schoolhouse was just one of many early Long Island schoolhouses. Most were demolished, but this one was rescued. It is seen here in about 1952, before it was restored by the Nassau County Department of Public Works. It was opened in 1959 as an exhibit on early Long Island education in Manhasset Valley Park.

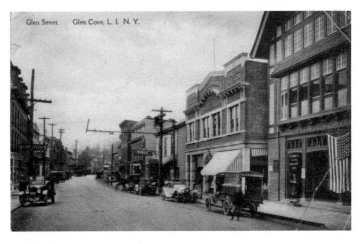

Glen Street. Glen Cove, L. I. N. Y.

A thriving Glen Street in Glen Cove is depicted circa 1920s; the Glen Cove Post Office is at right. Downtown business in towns along the waterfront boomed during summers when the local population swelled.

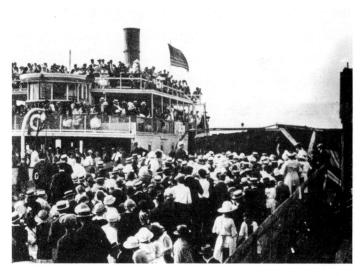

The ferry at Bayville ran from the Wall's Beach dock to Rye, New York, in Westchester County (seen in 1920). Ferries made it easy for people from Westchester and Connecticut to reach Long Island. Ferries had been operating at Bayville for almost two hundred years by 1920.

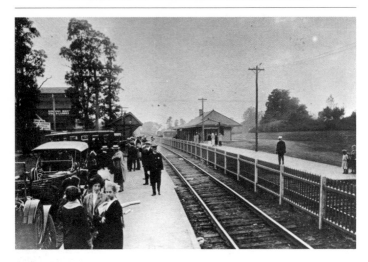

The Long Island Rail Road brought passengers from New York City to various business and vacation spots on the North Shore. It was one of the most important factors in the successful development of the North Shore. This is Locust Valley Station in about 1910.

Opposite above: The view from the Downing House in Mill Neck, about 1908. The house, formerly home of a judge named Downing, was owned by the Brooklyn Young Women's Christian Association and served as a summer home for girls. It was destroyed by fire in 1911.

Children in front of a schoolhouse in Huntington, circa 1907. How long children attended school depended on their particular family situation; for example, children of wealthy parents were more likely to continue their schooling, while farm children might leave early to work full time on the farm.

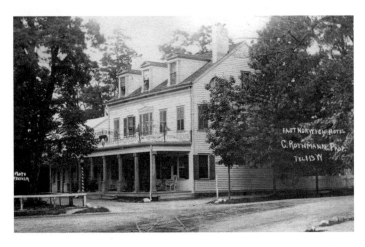

The East Norwich Inn, seen circa 1920s, was run by proprietor C. Rothmann. Located at the intersection of North Hempstead Turnpike (Route 25A) and Jericho-Oyster Bay Road (Route 106), this spot now houses two separate facilities: Rothmann's Steakhouse and the East Norwich Inn, located behind it. The two roads were widened considerably in the 1950s, eliminating much of the intersection's old-time charm.

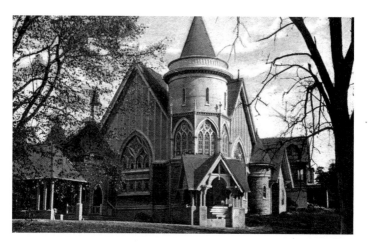

The First Presbyterian Church in Glen Cove was built in 1906 in the Tudor style. Seen in this photograph not long after it was constructed, the church still stands today, though the exterior has been renovated to present more of a traditional half-timbered appearance.

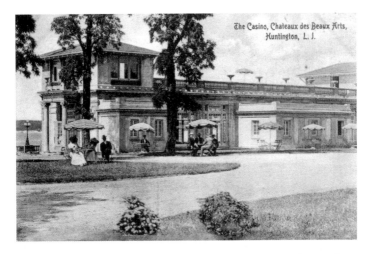

The Casino, Chateaux des Beaux Arts, Huntington, L. I.

The Chateaux des Beaux Arts in Huntington was located on a four-hundred-acre waterfront property. Built in 1907, this hotel was designed by noted architects Delano and Aldrich. Depicted here is the casino end of the structure. The building was demolished in the 1950s.

The property of George Hewlett at Great Neck as it appeared in about 1880. The fifty-five-year-old Mr. Hewlett lived here with his wife, two daughters, two sisters and six hired help. The Hewlett family first came to own this land, a 250-acre plot known as Hewlett's Point, in 1756.

Two brothers rest in a barn at the Old Place, longtime home of the Hicks family in Old Westbury, in this image by amateur photographer Rachel Hicks, circa 1885. There are still plenty of barns left on the North Shore, but the working farms are mostly gone, except in eastern Suffolk County.

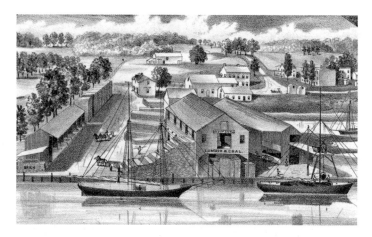

The lumber and coal yard of James Thorne, Glen Cove, circa 1880. Thorne began dealing in lumber, shingles, coal, lime, cement and brick in 1858, when he was twenty-three years old. He was soon generating $50,000 in revenue per year. Industrial development along the Glen Cove waterfront would later become a problem, causing contamination of the soil and water and creating a decline in tourism.

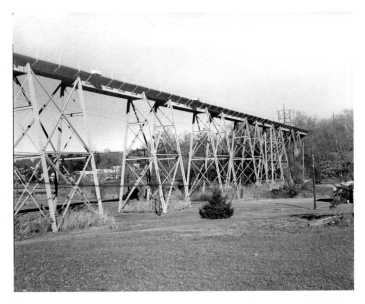

Construction of this eighty-foot-high Long Island Rail Road bridge at Manhasset in 1897 enabled railroad service to reach Manhasset and Port Washington, thus bringing many vacationers from the city.

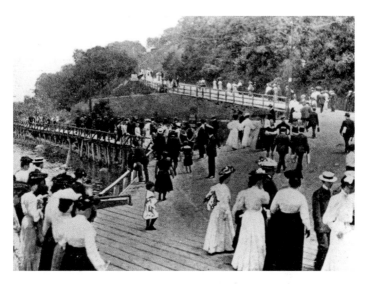

Sea Cliff was a very popular destination for summer vacationers during the Victorian era. Steamboats brought visitors by the hundreds to the quaint village that offered fresh air and seaside fun. Here, people walk along the boardwalk near the steamboat dock, circa 1900.

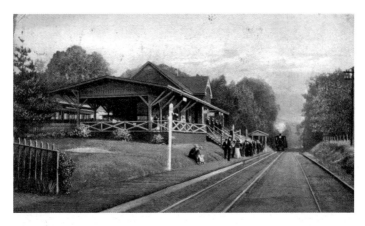

A picturesque view of the railroad station at Sea Cliff as it appeared in about 1905, at the height of Sea Cliff's popularity as a summer resort. The original station was built during the 1860s and was replaced in 1888. The structure is on the National Register of Historic Places.

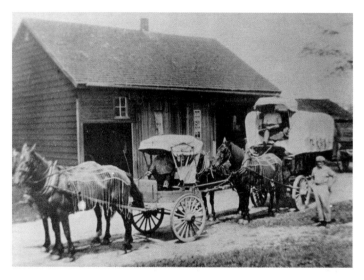

Myron Poole in the wagon at right, with Edgar Poole at left and Victor Roman standing, circa 1908 in Manhasset. The farmers brought produce from their farm on Shelter Rock Road to the Harlem Market, fourteen miles distant.

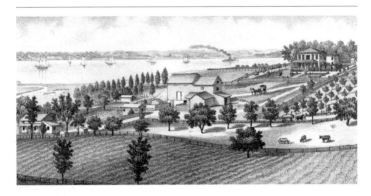

The residence of John Schenck in Matinecock, seen in an 1880 lithograph. In 1997, Matinecock, population under one thousand, was voted the richest town (according to home value) in the entire United States.

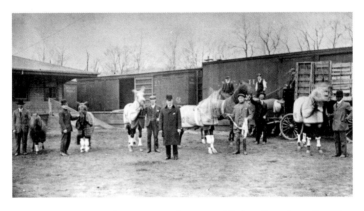

A coachman named Hennessy and some stable hands wait at the Glen Street Station in Glen Cove, with prize stock, circa 1910.

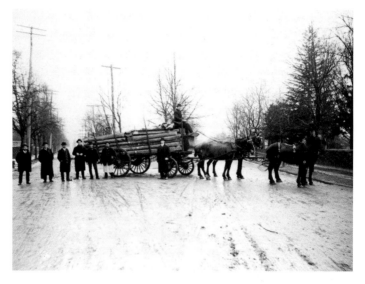

This image depicts the removal of parts of the original Abraham Lincoln log cabin from College Point (where it had been discovered in storage in the basement of the Poppenhausen Institute) in February 1906, to be reerected on the Lincoln farm at Hodgenville, Kentucky.

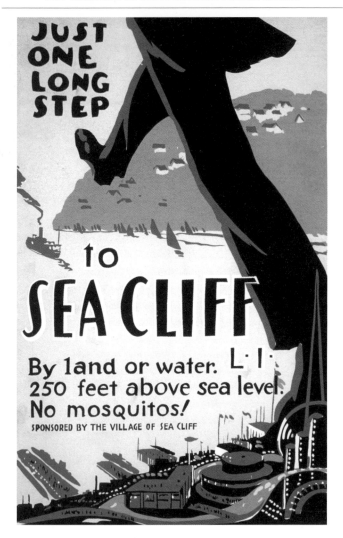

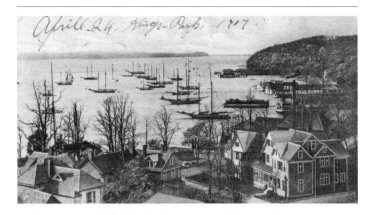

A view of the Northport Harbor in 1907 shows about 20 boats anchored. The North Shore has always been popular for pleasure boaters because of its relatively calm waters. In 1959, there were an estimated 375,000 boats on Long Island.

Opposite: This Sea Cliff poster was designed as part of a WPA federal art project between 1936 and 1939. It, and other posters created during the 1939–40 World's Fair, was meant to attract visitors back to a place that had needed no advertisement around the turn of the century.

Members of the Earley family of New Hyde Park visit with their friends the Filaskys at the Filasky Farm in Upper Brookville in 1941. Like nearly all farms in Nassau County, the valuable land has since been sold for development.

Historic Structures

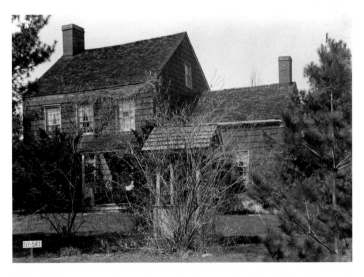

Walt Whitman was born in a farmhouse in West Hills, Town of Huntington, in 1819. The home has been preserved and is on the National Register of Historic Places.

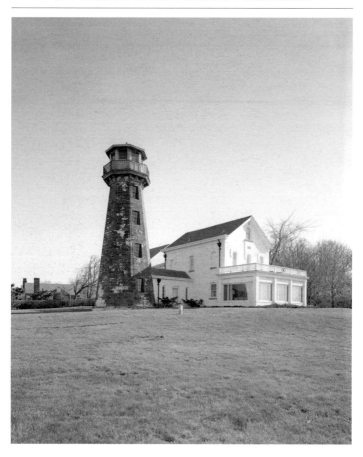

Lighthouses played an important role in North Shore history, as ferry traffic between Long Island and Connecticut and other ship traffic was heavy during the eighteenth and nineteenth centuries. The Sands Point Lighthouse was built in 1809 near "Kidd's Rock," the spot where Captain Kidd had allegedly buried some treasure.

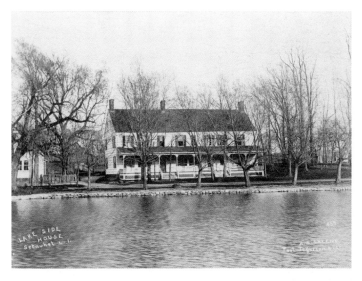

This is an image of the Lakeside House, an inn on Main Street in Setauket, circa 1900. The building was built in the early 1700s and was moved from Setauket Bay to Main Street in 1820. It was first known as the Elderkin Inn, and then as the Lakeside House. The building was donated to Setauket in 1918 and is now the Setauket Neighborhood House.

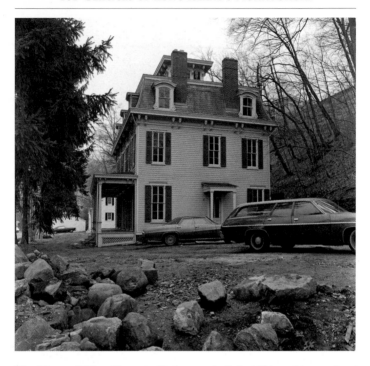

The Warren Wilkey House in Roslyn was built in 1864, and is seen here about one hundred years later in a photograph taken as part of the federal government's HABS program. Roslyn is known for its beautiful Victorian homes.

Opposite: The First Presbyterian Church of Huntington (125 East Main Street), built in 1784, is the third church on the site. Seen here in the 1930s, the church was designed by a New York City architect but built by members of the congregation. The British had dismantled the second church during the Revolution and the materials were used to build a fort.

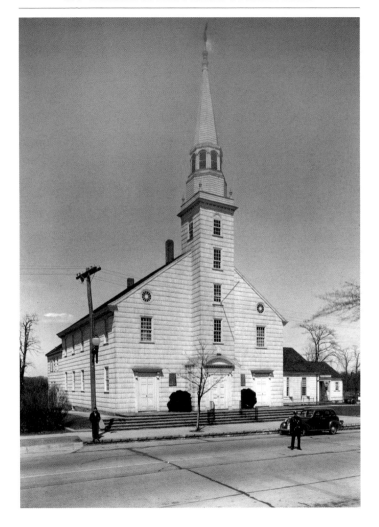

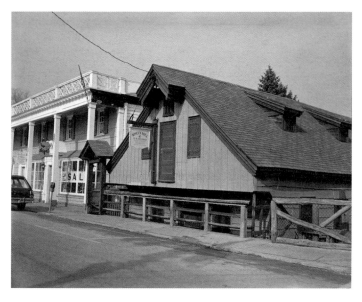

The Robeson-Williams Grist Mill is one of the oldest mills on Long Island. First built in 1701 and rebuilt in 1735, it is located on Main Street in Roslyn. It is seen here in a photograph taken in the 1960s. The mill is in need of a major restoration that will allow it to be opened to the public.

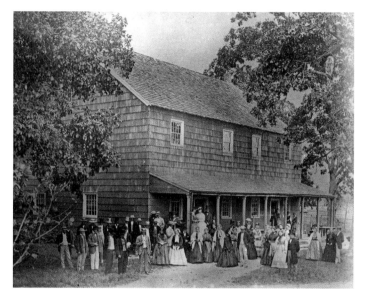

The Quakers had a strong presence in North Shore communities. By the early 1700s, they were holding meetings in Oyster Bay, Matinecock, Westbury, Flushing, Cow Neck, Huntington and Setauket. This is the Westbury Quaker Meetinghouse (built circa 1800) as it appeared in 1869, at the corner of Jericho Turnpike.

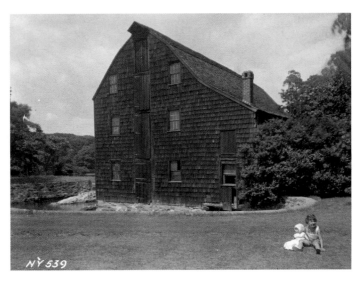

The mill at Saddle Rock on the Great Neck peninsula was built circa 1700 on Udall's Pond. It was known as Eldridge Mill when this photograph was taken in 1937, a few years before the mill was first restored. Nassau County now owns the property.

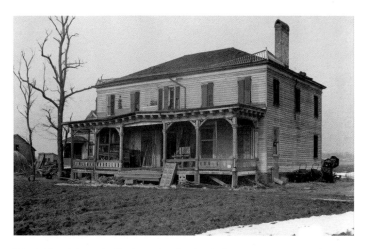

The Kelsey House (built circa 1818 by Edwin Willets) on Lakeville Road in New Hyde Park was the fourth house on the site. Tenants of earlier homes on the site included Thomas Dongan, governor of New York during the 1680s; Josiah Martin, who became governor of North Carolina; and George Duncan Ludlow, who became governor of New Brunswick, Canada. At the time it was photographed in the 1930s, the house was damaged by fire and mostly abandoned, destined for demolition.

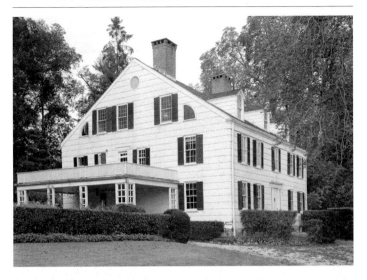

The Georgian-style Joseph Lloyd Manor House in Huntington was built in 1767. Lloyd Harbor is named after the prominent Lloyd family.

Opposite: The Horatio Gates Onderdonk House, built 1836 in the Greek Revival style, was named after its owner, who had law offices in Manhasset and New York City. Onderdonk, the grandson of Adrian Onderdonk, first supervisor of Manhasset, was also a judge in Kings County for a time. The house, located at North Hempstead Turnpike and Strathmore Road, is seen here as it appeared in 1936.

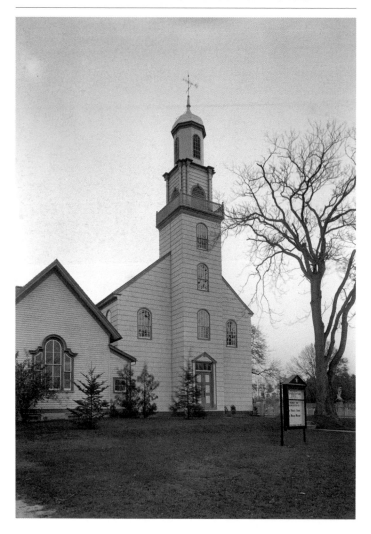

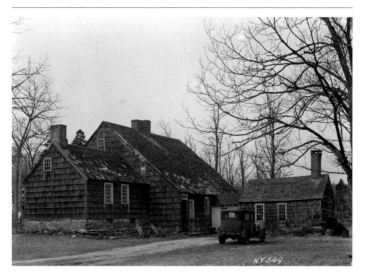

The Benjamin Franklin Thompson house in Setauket as it appeared during the 1930s. Thompson, born 1784, was a local historian who wrote the landmark book *A History of Long Island* in 1839. He also helped establish a public library at Setauket.

Opposite: The Setauket Presbyterian Church, on Caroline Avenue in Setauket, was built in 1812 in the Federal style. The congregation, one of the oldest on Long Island, had been formed in 1660.

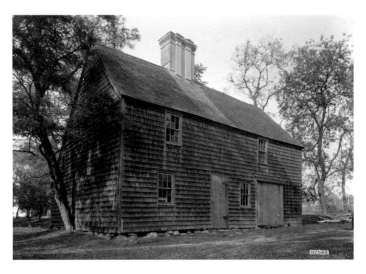

The Horton-Wickham-Landon House in Cutchogue was built in 1649 in Southold and moved in 1661 to Cutchogue. One of the oldest structures on Long Island, it is now a National Historic Landmark.

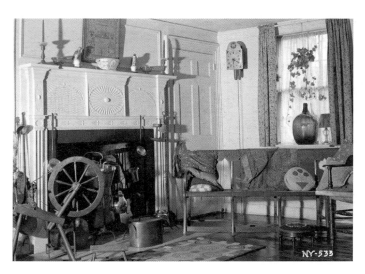

The interior of the Willis-Post House, located on Willis Avenue in East Williston, is seen here in 1936. Note the elaborately detailed fireplace mantel. The home was built about 1800. The Willis and Post families are two of the oldest on Long Island.

Mansions and Estates

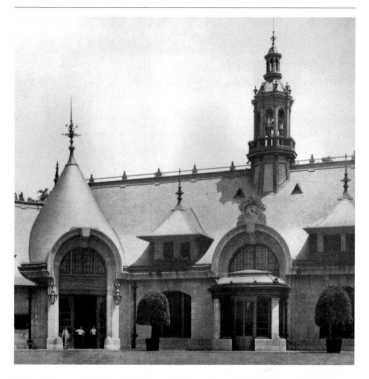

This photograph shows Harbor Hill's main stable, designed by Warren and Wetmore, a well-known architectural firm. The grounds occupied five hundred acres with many buildings, including kennels, a polo pony stable, a farm barn, chicken houses, conservatories and a dairy.

Opposite: The Harbor Hill estate in Roslyn was the home of a financier named Clarence Mackay. Designed by McKim, Mead & White, the home was on a hill 368 feet in height that looked out to the head of Hempstead Bay. The home's bathtub was carved from a single piece of marble.

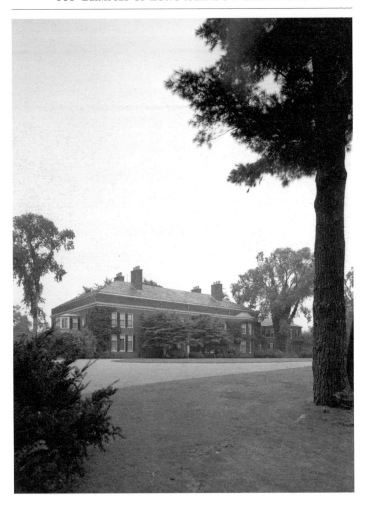

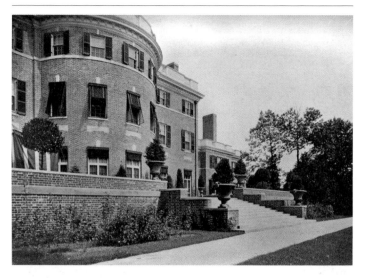

The Canfield House in Roslyn, seen in 1904. The home of Josephine Houghteling Canfield (widow of A. Cass Canfield), the building was designed by McKim, Mead & White.

Opposite: Welwyn, the Harold I. Pratt House in Glen Cove, was built in 1913 for the oil magnate and member of a wealthy local family. The mansion now serves as a Holocaust museum and learning center and the surrounding waterfront property is the Welwyn Preserve.

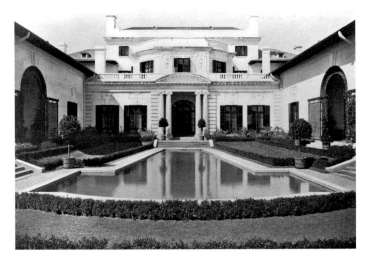

The courtyard of Knole, the Herman B. Duryea home in Old Westbury. It was designed for the race horse owner by the famous architectural firm Carrere and Hastings, and was completed in 1903. The home was three stories in the front and two stories at the rear, located on a hillside and surrounded by woods.

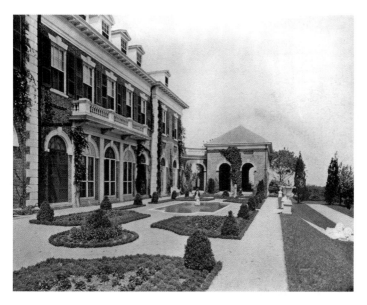

The home of General Lloyd Bruce (seen here in 1904) was built in Roslyn overlooking Hempstead Harbor on property that had once belonged in part to William Cullen Bryant. In 1919, the property was purchased by the Frick family. The building now houses the Nassau County Museum of Art.

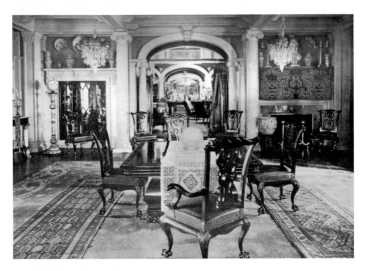

Martin Hall, the house of James E. Martin, Esq., of Great Neck, was located on a cliff overlooking Little Neck Bay. It is seen here in 1904, a year before Martin was killed in a car crash riding between Bayside and Flushing. He was said to have left an estate worth $700,000.

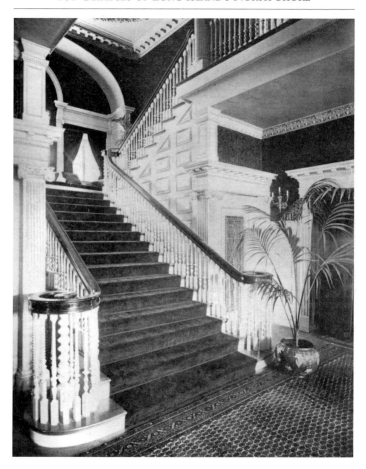

Rosemary was the house of Foxhall Keene (a polo player, golfer and auto racer), located in Old Westbury. The drawing room featured a custom-made Italian walnut Steinway piano. Seen here is the grand staircase of the Keene mansion.

The Stanford White house in St. James was designed by Mr. White himself, an architect with the famous firm of McKim, Mead & White. From the front porch, one could see Crane Neck Point, Stony Brook Harbor and Smithtown Harbor.

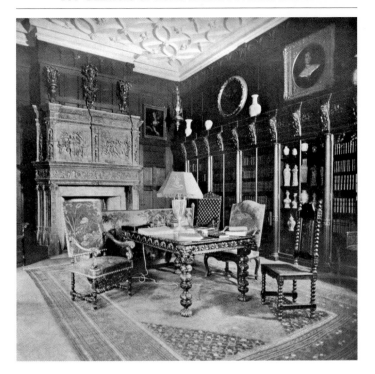

The W.L. Stow House library in Roslyn featured a Venetian carved mantelpiece and displayed a collection of blue and white china on the bookshelves.

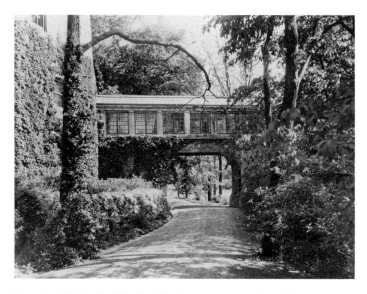

Laurelton Hall in Cold Spring Harbor was the mansion of Louis Comfort Tiffany, the famous master of jewelry and stained-glass design. Located at Laurel Hollow and Ridge Roads, the mansion was designed by Tiffany and completed in 1910. This is a 1920s photograph of a covered bridge on the property. Laurelton Hall was demolished during the 1950s.

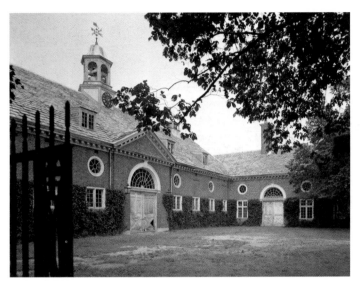

Caumsett Manor was designed in 1924 by John Russell Pope for the department store magnate Marshall Field. Located in Lloyd Neck, the estate eventually was purchased by the state of New York and became a fifteen-hundred-acre state park, with many buildings still intact. Shown here is the Caumsett Polo Stable. The word Caumsett was a Native American term for the area, meaning "place by a sharp rock."

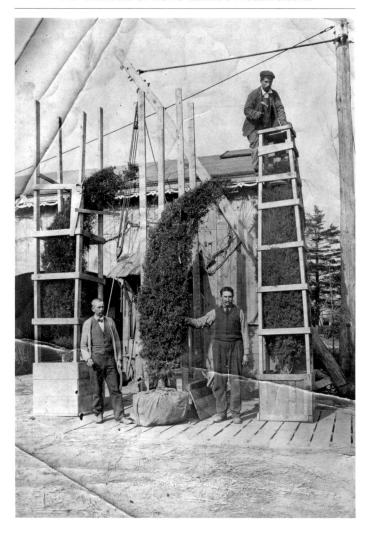

This photograph shows the north elevation of the Fort Hill mansion in Lloyd Neck. It was originally built in 1879, and was added to by a later owner, William Matheson, a wealthy dye merchant who had founded the Allied Chemical Company. The estate underwent a major restoration in the 1990s.

Opposite: Hicks Nurseries of Westbury transported and planted hundreds of fully grown trees on numerous North Shore estates during the late nineteenth and early twentieth centuries. In this photograph, workers at Hicks are wrapping a tree for delivery.

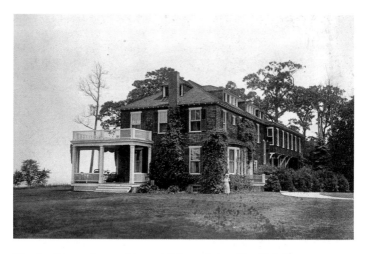

Charles Dana, the wealthy publisher of the *New York Sun* newspaper, purchased an island called Dosiris off of Glen Cove in the 1870s, where he had a mansion built. He died in Glen Cove in 1897.

Fun and Recreation

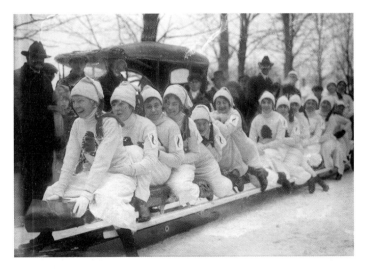

The annual bobsled "carnival" in Huntington was a race that drew many spectators. In 1915, there were fourteen competitors from various North Shore towns. The February race was won by the bobsled called 1911, which was owned by the Matinecock Neighbors Association of Locust Valley. Their prizes were a silver cup and fifty dollars. Shown here is the Grey Hound team. The backs of their sweaters said "Votes for Women."

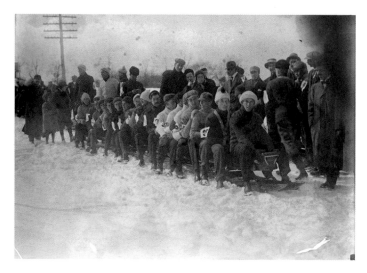

The Huntington bobsled of Cold Spring Harbor came in a close second place in the 1915 race held in Huntington. The races were canceled after ten women were injured when their bobsled crashed in the 1920 race.

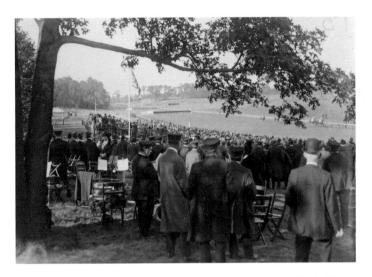

Horse racing was popular in various locales along the North Shore, including the Piping Rock Club at Locust Valley. The club was founded in 1911 by residents of Glen Cove, Oyster Bay, Roslyn and Westbury. In addition to a racecourse, the Piping Rock Club also had polo fields and a hunting course. This image of a horse named Cherry Malotte winning a race at the club dates to 1913.

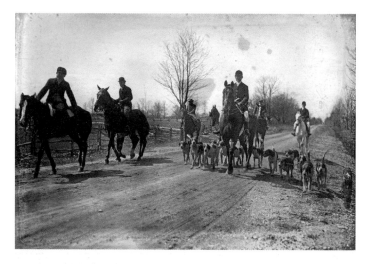

The Meadowbrook Hunt Club was a popular fox-hunting club during the late nineteenth and early twentieth centuries. The hunts took place in various places, including North Shore locales such as Wheatley and Locust Valley. Once, the club met in Oyster Bay at the home of Theodore Roosevelt.

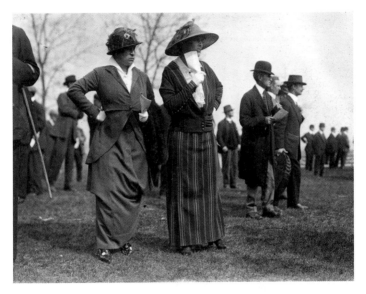

Two women anxiously watch the Wheatley Hills races run at the annual meeting of the Meadow Brook Steeplechase Association on the estate of Harry Payne Whitney on May 9, 1914. There were five races run, with the biggest prize, $300, going to Indicator.

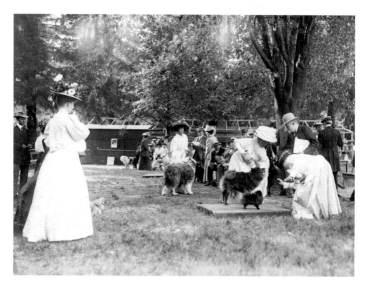

Dog shows were held at Mineola as early as 1874. This image depicts the judging of chows and Pomeranians at the Mineola dog show in June 1908. On the cusp of the North Shore, Mineola Station was also the gateway to many of Nassau County's North Shore communities. Events held there drew many of the wealthy North Shore estate owners.

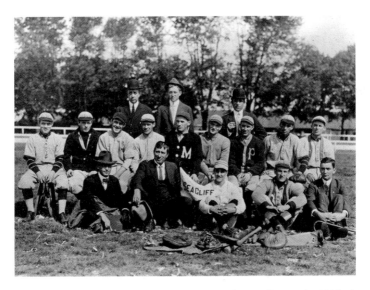

The Sea Cliff baseball team, champions of Nassau County in 1912. A newspaper article in 1907 proclaimed: "Sea Cliff Likes Baseball; Guests Follow the Local Players with Keen Interest."

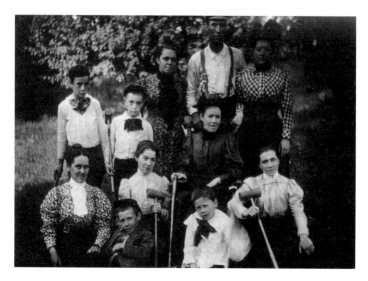

The Meagher group, August 1898, posing with croquet equipment in Manhasset. Popular in Europe, croquet spread to the United States during the late nineteenth century and was especially popular on the well-groomed estates of Long Island's North Shore.

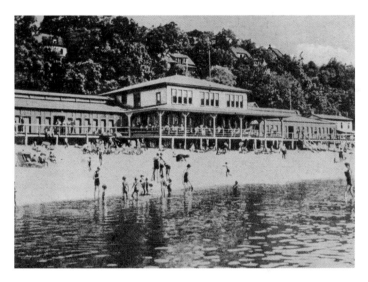

The Sea Cliff Bathing Pavilion as it appeared in 1910. Sea Cliff was conceived specifically as a resort town during the early 1870s. It was intended at first to provide temporary residence, but the location proved so favorable it soon became filled with permanent homes.

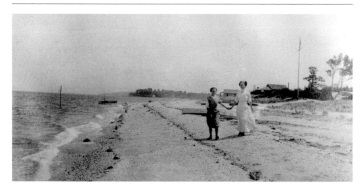

Two women pose on the beach in Bayville, circa 1910. Great Neck, Glen Cove, Locust Valley and Bayville were popular recreation spots because of their proximity to New York City. Nonetheless, it wasn't all play for the men who brought their families to the North Shore. During summers, the number of commuters to New York City in many North Shore communities increased.

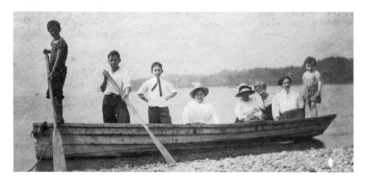

A group of vacationers prepares to take a rowboat out into Hempstead Harbor near Port Washington in 1912. The protected coves and harbors of the North Shore make for excellent swimming and boating.

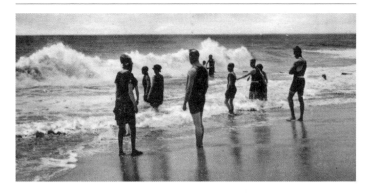

Bathing at West Meadows Beach in Port Jefferson, seen here during the 1920s. Though there were many miles of beachfront that were privately owned by the wealthy estate builders, the North Shore offered plenty of public beaches as well.

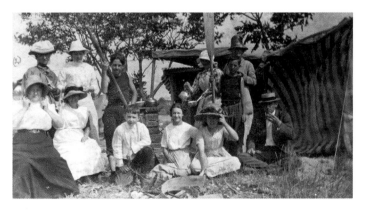

Members of the Bennett, Lascelle, Tatem and McCord families visiting from Westbury attended a summer camp at Bar Beach (now North Hempstead Beach Park) in July 1912.

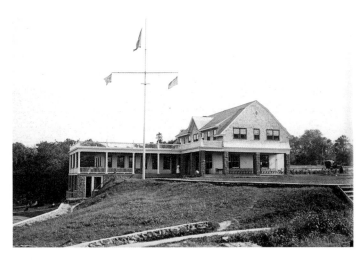

The Bayside Yacht Club was founded in 1902. In little more than a decade, the club had attracted 250 members from Bayside and surrounding communities.

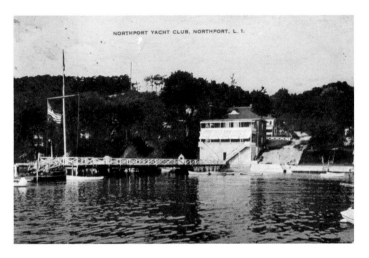

The Northport Yacht Club (founded 1899) is seen as it appeared in about 1915.

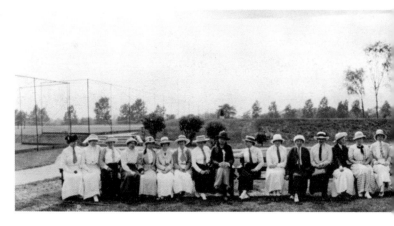

Participants in the Women's Metropolitan Golf Championship pose at the Nassau Country Club (founded 1899) in Glen Cove during the 1913 competition.

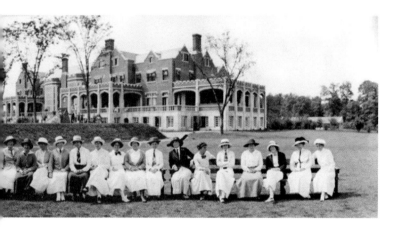

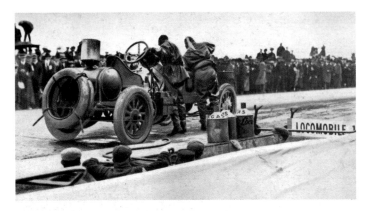

North Shore spectators, including many of the rich and famous estate owners, flocked to the grandstands to witness the Vanderbilt Cup races that were held on Long Island between 1904 and 1911. In 1906, the racecourse ran through East Norwich, Brookville, Roslyn and Manhasset. In 1908, the course skirted the edge of the North Shore, running through Jericho, Woodbury and Locust Grove. In this picture, the winning Locomobile of the 1908 race stops at the end of the ninth lap to take on gas.

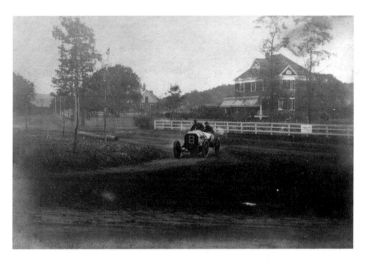

A race car tears down a road in Old Westbury (probably the intersection of Wheatley Road and Store Hill Road—now the north service road of the Long Island Expressway), circa 1906, possibly during or in preparation for the Vanderbilt Cup Race. In 1906, car number 8 was a Fiat driven by Nazarro of Italy.

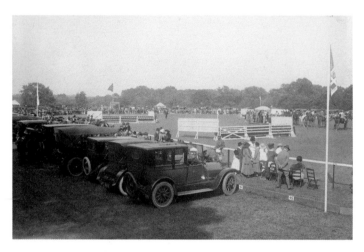

Cars parked at the Piping Rock Club, circa 1910. The automobile helped transform many areas of the North Shore from quiet oases to popular recreation spots, by allowing people to easily reach places not directly served by the railroad.

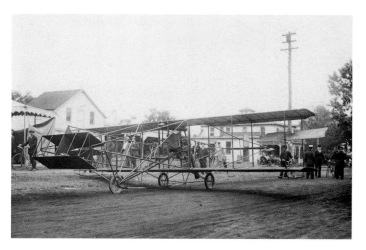

North Shore residents were among the few people in the country who could look up in the sky before 1910 and see airplanes flying. One of the main fields was located in Mineola. The Herring-Curtiss Golden Flyer was flown by flight pioneer Glenn Curtiss at Mineola in 1909.

The America Trans Oceanic Company conducted a summer aviation school at Port Washington. Its waterfront location made it perfect for the use of seaplanes. In 1921, two seaplanes lent by the United States Navy were kept there.

Opposite: A flying boat at Manhasset Bay in Port Washington, circa 1917. In the summer of 1916, Aerial Coast Patrol Unit No. 1, a twelve-man volunteer unit, was trained at the Port Washington Flight School.

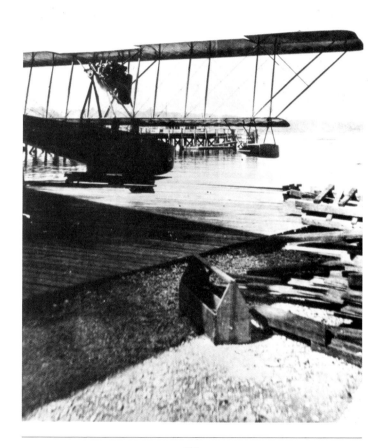

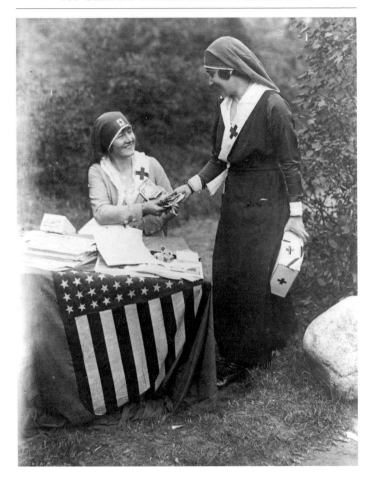

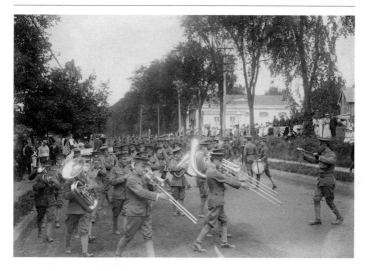

Members of the National Guard made an appearance during a celebration at Great Neck in September 1913.

Opposite: About five hundred actors and extras took part in a benefit show for the American Red Cross, held in Huntington in October 1917, not long after the United States entered World War I. In this photograph, actresses Frances Starr and Bijou Fernandez count the money raised during the event. Famous participants in the benefit included Ethel Barrymore and Tyrone Power Sr.; bandleader John Philip Sousa led a concert before the show.

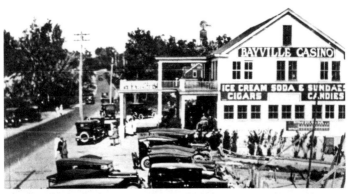

Bayville Casino as it appeared in 1913. It burned down in 1923. Located across the street from the beach, the casino was on what would be the site of the Oak Neck bathhouses, which were destroyed by the hurricane of 1938.

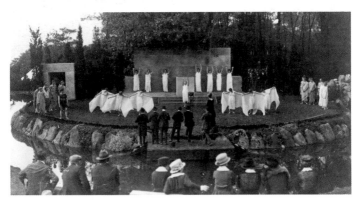

The open-air Rosemary Theatre at the Roland Conklin estate in Huntington was on a hill overlooking an inlet of the Long Island Sound. Occasional shows were put on at the theatre, including a war-related revue in 1917 and three ballets in 1919. Thousands of spectators arrived by train and car to witness the Rosemary Theatre productions.

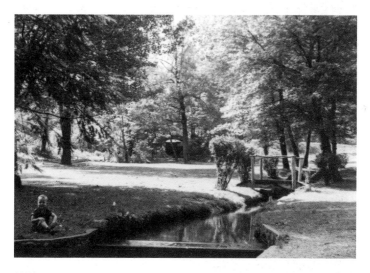

Since it opened in 1931, Roslyn Park has been one of the most popular and pleasant parks on the North Shore, becoming known for its duck pond. A child enjoys the park in this photograph from 1954.

Visit us at
www.historypress.net